Do I have an
Angel?

by Amanda Tooke

PIXEL**TWEAKS**PUBLICATIONS

First published in Great Britain 2013 by
Pixel Tweaks Publications, Ulverston, Cumbria.

ISBN: 978-0-9927514-1-8

www.pixeltweakspublications.co.uk

Aknowledgements

There are many people I would like to thank that made my book possible. They are listed in no particular order.

Morag Leiper for looking after my shop giving me time to write. Janine Hatfield and Kristel Kemp for proofreading. Russell Holden for advice and the layout. Pete 'the pen' Langley for the cartoon images.

All the wonderful Angel stories from Jill Turner, Lisa Lydka, Angela Edwards, Pamela Weedon, Diane Toogood, Stephanie Pugh, Edwina Scott Russell, Alan and Sandra Marsh plus the others that wanted to remain anonymous.

Most of all I have to thank "The Upstairs" for all their assistance in this and everything else in life.

Amanda Tooke

Dedication

To my wonderful children Corrie and Brad for their
continual support in the work I do.

I appreciate it is not easy having a Mum with an
alternative career but I am very grateful for you
always listening to me and believing in me.

Contents

Introduction

Do I have an Angel, is a question many ask. This book will explain that you most certainly do and how you may experience yours. Over the years that I have been teaching others to connect with their Angels, I have realised everyone's experience is likely to be different, but each one is true and valid. We are all individuals, and nobody knows us better than our Guardian Angels, they will communicate exactly how you need them to.

This book is about introducing you to your Angels and how they can help you with your life. With that in mind I want to offer you a simple, fun, uncomplicated way to connect, so you can learn about Angels, their signs and how the Angels can help you. It is packed with all the information you will need and a simple exercise where you can meet your Guardian Angel and maybe even learn their name.

In a nutshell, Angels can help you with everything; you just have to ask; it really is as simple as that. But, throughout the book, I will explain in more detail about Angels and how I came to use them in everyday life, and how with them my life has turned around into something quite extraordinary.

I will share with you my real life story, explaining events that the Angels have influenced, and also give

you examples of both mine and some of my clients wonderful encounters with their Angels. I believe it is good to question what you will read and ponder over things, giving these matters some thought. I would even suggest it is good to be a sceptic until you have proof. Your Angel is waiting, ready to prove their existence, so you have nothing to lose discovering yours.

The book is a short guide that is clearly labelled, you can start at the front and work your way through to the final page, or work with your intuition and read the section you are drawn too, returning to the other chapters when the time is right for you. Taking in as much or as little information as you need, personalising it, just like the Angels personalise their communication to you.

By doing this, it will mean you can develop your relationship with the Angels and with yourself at your own speed, and in your own time. So you can become your own expert on your own Angels and most importantly your own expert on yourself, by developing your intuition, too. You will be able to receive the help that you need from inner strength to real practical help and it is all waiting for you now.

I understand this is going to require some trust, and that is not always easy, after all I am asking you to trust something that is invisible to most! So, I know there

will be periods when you don't believe you are being answered and getting the help you believe you desperately need. But this book is not just an easy guide to connecting with the Angels, it will also give you advice when you become unstuck and disconnected; we can all get it wrong sometimes.

Chapter 1

Why now is the time to discover your Angels

"Now is all we have and all that is important, the past is behind and will not stop your Angel loving you unconditionally working with you to create a fully supported future."

This is a really exciting time, more and more people are becoming open to the fact there is more to life than what we can see. Whilst Spirituality is still in the minority, I know just in my own experience that so many are opening up, and more and more children are being born with super psychic gifts. It is more openly spoken about, so it is a perfect time to discover your Angel. After all, you wouldn't want to miss out on something so special would you?

You don't need me to remind you of the problems the world is facing both further afield and closer to home. But, as humans, we have created this world. I believe everyone should connect with their Angels

and live their lives with a flow of love, respect and honesty. Connecting with their inner guidance system (intuition).

This is because Angels come from a place of love, they are pure love, they love you unconditionally, and this can't help but have a big effect on you. You become more loving and accepting of yourself, others and the world around you. You want the best for all concerned, and I find I am asking the Angels all the time for not just help for myself, but for others too, whether I know the people or not.

The Angels all understand that we are not Angels, we make mistakes, get it wrong, and they still love us. We are not meant to be Angels, but with their love and guidance, I believe it makes us all nicer, more caring people, so that has to be a good thing.

I believe we are here to have experiences, many that we learn from. In fact, Earth is school for the soul. So many areas of humanity have become too material-istic, money and greed took over. But thankfully, now many are realising abundance comes in many forms.

"The Upstairs" is a collective term I use for the folk that sit up above, our loved ones that have passed over, our Angels and Spirit Guides. I believe everyone can connect with them, there is nothing complicated about it, but it does require oodles and doodles of trust.

I like to think of trust in the same manner as when we switch on a light. We go into a dark room we know, and by flicking a switch the light will come on. We know because we trust it will. Sure there will be times when there is a power cut, but it is short lived and we know it will return again when the connection is made. That is what working with your Angels is like. You trust they are there and they will be, but there will also be times when the connection is not made and you feel left in the dark. Further into this book I will explain how to get through this and trust how they are still there, just as the electric is still there, it is the connections that are wrong.

Chapter 2
The Transformation

"I often use the word 'we' instead of 'I', because I feel I am never alone and always have my Angels with me"

I say the Angels have turned my life around, turned it upside down. But the reality of that is that it was upside down before, I was bobbing along, struggling to make ends meet, with little direction, nothing really making sense, doing what I thought I should do, what was expected. Now, it is the right way up and makes complete sense, all because I connected with my Angels!

The journey, of course, started with Angels and they have supported me along the way, but this was only part of it. I have discovered my Spirit Guides and how they change throughout my life. Some being family members, some being old souls with wisdom that offer guidance to help me through a particular period. I have embraced the learning on my spiritual journey, and expanded my mind

to understand things I could never have dreamed of previously. I understand many of my previous past lives, have grown as a person and have embraced my spirituality. I have learnt the importance of being safe when working with Spirit and developed exercises in grounding and protection. I have always realised there is more to this life than what we can see. Now I understand far more about the invisible realms and most of all, I understand me.

Looking back, I should have realised long before I did. As a child I felt different, didn't quite fit in with anything really. The saying "square peg in a round hole" sums it up. This, however, did not stop me trying to fit in, doing what was expected; I morphed myself into many things over the years, even though it pained me to do so.

Countless times I have said to myself "I knew that would happen". I just didn't understand how I knew. I didn't understand it was my sixth sense or my "pyshicability" as we call it! So, I didn't act upon it often enough, so there were, and still are, mistakes. But that is life, nobody is perfect.

Still, back then working in various jobs such as family businesses, social services and even as a beautician, never in a million years did I think I would be doing what I am now, but I couldn't be happier working with the Angels; well, why wouldn't I? They make everything so much easier.

This was a journey of self-discovery, but not just me in this physical life but working with my soul and my previous lives. It is only now I really understand myself and I am comfortable in my own skin. I do really like me and if you do that is great, but if you don't that is your issue and not mine. This may sound harsh, but it has been a long and difficult journey to get to this point, and it was all made a lot easier when I connected with my Angels.

My wonderful Nana

I grew up in Rainford, with my Mum, Dad and younger brother Andrew, but also my wonderful Nana, Alice. She lived with us and played an enormous role in my life and most importantly started my interest in spiritual development. She was the one that brought up the conversations that I found fascinating; like how we don't really die, life is eternal.

My first psychic experience was about my Great Grandma. I was about 12 years old and walking home from school with a friend. As we were walking along and chatting I just came out with, "My Great Grandma has died." "Oh, when?" she said. "Now" I replied. I remember clearly she wasn't quite sure what to say to that, I was really taken aback too, as nothing like that had happened before. When I got home I found my Mum and Nana sat in the kitchen upset because they had just had news Great Grandma had died.

But nothing could have prepared me for my own Nana's passing as she had played such an important role in my life when she was still on the earth plane. I didn't realise then she was going to prove to me that we don't really die.

As a small child, on many occasions, I can remember lying in my bed tossing and turning. It was warm and comfortable with my flannelette sheets, but I could not sleep because the energy in the house often unnerved me, I was scared. Like all houses it made noises like creeks and cracks, but it was not just that. Did everyone experience this? The voices, noises, shapes, shadows and faces. But once I heard the front door go and my Nana come in I could relax. She used to go and visit my Great Grandma and sort her out for bed. She would walk home and come in to see me when she got back. Her hands were cold from the night time air and she would put them on my head. I would instantly relax and feel better. Looking back now I realise she was a healer, though I am not sure even she knew that.

We would swap news and often she would say about people passing over. We would talk about lots of things and she made up the best stories for bedtime, but I was comfortable telling her how I was scared to die, and also see a dead person. Nana went into detail about how people look the same just as if they are asleep, that there was nothing to fear, life went on.

I loved to spend time with her. I went with her wherever I could, including regular visits to the local C of E church. I never felt comfortable in a church and I have since found out why as it relates to my past lives of being killed in three different life times by churches for prophesy. But I was more than comfortable in the company of Nana, sometimes we did not even have to talk. Just sitting close was enough to feel comfortable in her energy.

This made more sense much later in life as I realised this happened again as Nana had become ill with Alzheimer's. Mum looked after her wonderfully at home for as long as she could, until it just became too much and sadly she had to go into a nursing home. Towards the end of her life the conversations became very confused and often comical, but it was still magical to sit in her company. It was peaceful, calming and comforting. Even though I did not find it easy visiting Nana at the nursing home I did try to go once a week. I hated seeing her in that lost state and I also hated the smell in the nursing home, but I loved to visit my Nana. As much as her words were muddled and lost, she still had that comfort. She would play with my hands and straighten my rings just like she used to do when I was little and lying in my bed with her cold hands on my face and straightening my hair.

She was such a fun lady, who loved to help so

many. She also loved family get-togethers, and I can remember a few occasions when Nana taught me and other family members to use a Ouija board. I understand the dangers of this now and would not recommend anyone to do it, but nevertheless Nana did.

Nana's passing hit me hard but was the trigger for lots more of my spiritual development. She now comes through to me so clearly for messages for me and other family members, she even still likes to tell me off!

The strange thing is when someone close to you has Alzheimer's you feel you have lost them as they are trapped in their lost world, even though they are still here in the physical. So, foolishly, I thought her passing would have been lessened by this as I had sort of already dealt with part of it. Well, I got that wrong. She lived to a great age of 95, which ironically was her 96th year. She had always said she wanted a round number on her gravestone as it looked nicer. As I have explained we had many conversations about death and passing over, she taught me so much and still does now as one of my Guides. At the time of Nana's passing I had a Bed and Breakfast. Nana had been very ill for quite a few days. It didn't take any specials skills to see her passing would be soon. I was visiting as much as I could, it seemed so important to be there for her. I sat

by her bed, holding her hand, talking to her about the things she had sat by my bed as a little girl and told me about.

Even though she was very frail and sleeping a lot, I know she understood what I was telling her. But we didn't always need words to communicate as our souls were connected, just as they still are now. I kept sending her the thoughts and just for backup kept telling her too. I was telling her that it was ok for her to pass, we would all be alright. It was her time to be with her husband and other family members that had passed before her. I told her they would come for her.

My Mum, Dad and Auntie were there too, and this was all happening at the same time I had to sell my business due to my ill health. I really didn't have a clue what I was going to do, but it didn't seem important then as we were all coping with the difficult period of what was inevitable, Nana's passing. But we were all there chatting to her, talking to each other, trying to make the time as pleasant as possible. Talking about the rest of the family and happy memories we all had. At one point, my Mum said to Nana, "so Mum, what do you think Amanda should do when she sells her guest house?" Of course she didn't answer; well, at least no words came out of her mouth. But as time unfolded I have come to realise she really did answer.

It was a slow process, but she had so much fight.

Each day passed into another night and so on, until the night came when she eventually passed. Unfortunately, I was not with her as I had a house full of guests and 2 children to take care of. But she was not alone, as Mum, Dad and my Auntie were with her. My Mum called to say she had passed, but I already knew. Even though I was asleep in bed I had been wakened with a strange sense of loss and I immediately knew she had passed over, so it was no surprise when Mum called. What was a surprise was how it affected me. I was beside myself with grief, just sobbing, I couldn't stop. There was a physical pain in my chest and I really didn't think something could hurt so much. I thought I would have felt relief for her and I am sure I probably did, but I was consumed in my own feelings of loss, then guilt for feeling that.

But who was going to make me feel better now? Just when I really needed her soothing touch she was not here to give it to me. I honestly did not know what to do or how I should feel. But then I got my first feeling to write, I can't describe it but it was an overwhelming feeling that I must write. I thought I would put pen to paper and write down all the things I loved about her and all I was going to miss. So, amongst the tears, I started to scribble away. I thought it would have been a list as that is what I intended to write, but no – it was a word perfect poem, and even stranger than that, it was all about Nana. I couldn't believe it; it didn't even

look like my writing. The next day when my Mum and Auntie came round to discuss arrangements, they asked me would I say a few words about Nana at the funeral, I showed them the poem and that is what I read out...

A quiet, kind, gentle lady, but knew how to have fun,
Full of mischief, smiles and laughter, games were such fun.
She really was remarkable and always very kind,
Always knew when something, was bothering your mind,
Her friendly face, her wave, a twinkle in her eyes,
Is special to all who knew her and made you warm inside,
Never the one to moan, just took it as it came,
She always made things better, she knew how to play the game,
The time she gave to others, makes me really proud,
A helping hand, a listening ear, entertainment all round,
She knew what was important, her family and her friends,
We are all going to miss her, but her memory never ends,
She had, a connection with all ages, we were truly blessed,
We are fortunate to know her, her empathy was just the best,
We are all so lucky to have had, a share of her wonderful life,
Her lovely, lovely smile, was always just so nice,
But you rest easy Nana, your hard work is done,
The Angels will look after you, but don't forget … have fun.

I didn't realise at the time but this period was the start of my automatic writing that I now call my Angelic downloads, and also was not the end but the

beginning of a new life, my Nana as my Spirit Guide, just as she had told me – life goes on.

So, like many people, birthdays and anniversaries can be a difficult day. December 13th is Nana's birthday and I was feeling quite emotional and missing her not being here in the physical form even though I can communicate with her in Spirit. I turned on the TV and an advertisement came on for Beautiful perfume, the exact one she wore. I smiled and acknowledged the sign she had just given me, she was just letting me know she was still here.

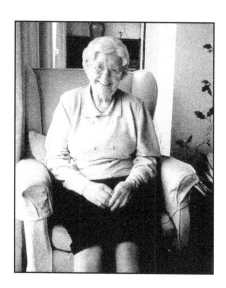

One of my lessons

Relationships are not something I have found easy, because you have to trust. It was not until I found the Angels that I found the true meaning of the word trust. Trust in the Angels is something else; it is amazing as they never let you down. There are still times when I still do think they are not listening to me, that they are not delivering; however, let me assure you they will be, but they are often very subtle with their signs.

From being small all I ever wanted was to be married with children. If I am honest it was the children I really wanted, the marriage was something I felt was expected from me if that was what I wanted. It was seen as the correct way to do things. I got what I wanted and I was married with 2 children. But sadly, I learnt nothing is forever, and as many marriages these days it ended. There is no pointing the fingers of blame as two people enter into a marriage and two people need to put the work in. For us I believe we got to a point that neither of us were doing that, hence the in-evitable divorce. But I do not regret it for one minute as I have my wonderful children who were 4 and 1 when the marriage ended. So there I was, my life had changed, my goal of being married had disappeared but I still had my children, and they, as many of us have learnt, kept me going. But what I didn't realise at the time – this was the start of a journey that gathered momentum for here on in, a journey of discovery of

what really made me tick and to find who I really was. This was the start of my connection with Angels.

After my divorce, I had to find myself a job and juggle childcare. Like the rest of the single parents out there I soon found this was difficult. I had been a stay at home Mum before this and just did my husband's books for his business. I was not really sure how I was going to cope. I found a job working at Social Services with a lovely bunch of people. This was a real eye opener for me, I really had nothing to moan about, so many people had far more to cope with. I juggled the job, training to become a counsellor and the children fairly well, with help from my parents, but no matter how careful I was I still could not make ends meet, and debts would arise. It became a cycle of re-mortgaging the house, paying off my credit cards, only to find I had to use them again and be back in the same position.

I loved doing my counselling training as I love to help people, and of course it was perfect as it brought with it a lot of self-discovery work. During this period, I had started to work with my Angels personally, and one day after listening to a colleague's problems, I told her to ask her Angels to help her and explained how I did it. I did add on the end though, "not to tell anyone as they would think I was mad". Even though I had no need to doubt them I was not confident in explaining my trust in these invisible realms. Little did I know that a few years down the line my life would be trans-

formed by them, and now I would be happy to tell the world about their help so others could benefit too.

The other thing I did not like about being a working Mum was not being at home for my children. So after a lot of careful consideration I decided to buy a guest house, so I could work from home. The only problem with this was the only one I could afford that was in a good position only had two bedroom owners' accommodation and there were three of us, plus our three little Yorkshire Terrier dogs. But not being deterred we went for it, as we all agreed we would share rooms. After the first season, I had improvement work done. In fact it seemed more demolition and construction than improvements. This, of course, created a great deal of dust, which led to a great deal of daily cleaning as I couldn't afford to close. So we stayed open and frantically cleaned, thankfully we had a lot of understanding guests staying at the time. That was quite possibly down to the Angels too. Unfortunately, halfway through the building work we found out we couldn't make the alterations as planned as we were trying to create a third owners' bedroom. So, we were back to the two again admittedly all much nicer facilities though. This meant I did not have a bedroom. As I have a boy and a girl I felt both children needed one each. So, I invested in a sofa bed and I slept in the living room.

Whilst all this was going on I became ill and had a severe asthma attack. I ended up in hospital leaving my daughter and my parents to run the guest house. Even after returning home I couldn't do very much without being out of breath. I had to have physiotherapy to learn to breath correctly, so many hospital appointments I began to think I lived there more than at home. All the while my parents were still doing all the physical tasks in the guest house. I had tests done and found out I was allergic to dust and dogs to name just a few, the reality was I seemed to be allergic to everything around me. The building work and living with the dogs in such a small environment seem to have triggered the attack. So a heart-wrenching decision had to be made about the dogs, we had to re-home our beloved Yorkies so I could get better.

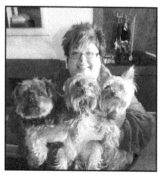

Boy, did I ask the Angels for help with that one, not only was it hard for me, but we all had a dog each so my children had to choose for either me to get better or re-home their dog. That was no easy decision, but thankfully this is where the Angels stepped in. All three dogs went to live with a local lady who I am sure is an Earth Angel, she has such an affinity with dogs she is

wonderful. All of them kept together, spoilt rotten, and the best bit was we were able to still visit them and the kids even took them out with their Dad.

It took me 6 months to recover and get back to controlled asthma. At first I found it difficult, day after day unable to do very little, but then one day I remember thinking I could use this time to meditate more as when I was running the guest house it left little time to do anything for myself. It was like a light bulb going on. I knew this was not going to be wasted time sitting around, but time to do what I had always wanted and have some time to develop. So this is exactly what I did and the spiritual development was incredible. I started receiving messages for family and friends via automatic writing, I was seeing more sparkles and flashes of light, experiencing more Angel signs, I even used to find that Spirit would wake me up in the night with messages which I was not comfortable with. So I realised I had to learn to control it and not it control me. I learnt to ground and protect myself, and also to not always be switched on, that way it was not draining, but almost energising and certainly exciting.

But then just as I got over my asthma attack I was made ill again, admitted to hospital with what they initially thought was lupus. But, this thankfully was not the case. Though it did seem that the hospital staff really didn't know what was wrong with me. What I did

know was I was in a lot of pain, very fatigued and just really didn't feel well.

This situation filled me with panic again; I couldn't run my guest house, again my parents had to step in, again all I could do was meditate. What was I going to do? My health was poor, I was not sure I was well enough to work for anyone else; I certainly could not run my business. How was I going to provide for my children? I made the decision I had to sell it, but what was I going to do? Not only did I need an income, but also a home for me and the children. It was a very dark time and certainly gave me some sleepless nights. I can remember thinking how I would have given anything to be still married and have someone to face this with and someone to look after me. Little did I know I had that already, once I had stopped panicking I remembered I just had to ask for the help I needed.

It was then I realised I had nothing to worry about; the Angels took care of everything. During all my meditating, they told me to go and view a shop which had been empty for a while. it had kept catching my eye. They told me what to sell, and I must do my readings which I have done for years for family and friends. I went to view with my Dad and my trusty pendulum. I think the landlady must have thought I was mad as I walked about it using my pendulum and getting clarification from "The Upstairs". As I stood in the shop

I looked across the road to the row of little cottages. I said, "Well, if am going to work here I want to live across the road and then I can be close for the children". The shop felt great, it was a step back from the road so all the energies whizzing past wouldn't just come in. It felt perfect.

I agreed I would take it on, and from viewing to opening the shop it took 2 weeks. The Angels guided me on what to stock and where to get it from. Everything went to plan.

The house across the road manifested with the help of the Angels too. We moved in once we completed the sale on the guest house. I am not saying all of this was easy, and it wasn't, but it was a lot easier with the help of the Angels.

Once I was settled in the shop, the next lot of instructions came. The automatic writing went mad and I ended up receiving an Angel Awareness Course, which I started to teach. The feedback was fantastic. So many others learning the benefits of Angels, I loved giving that to others, it gives me satisfaction beyond anything else I have ever done.

People realised that I was not the lucky one with Angels, but they have them too, but until then had never used them. I also received emails and communications from my workshop attendees telling me of their Angel stories, it was wonderful. It certainly beats

doing the guest house. Helping someone have a nice weekend break is a far cry from the satisfaction from helping someone receive the guidance and help they need to make their life better. I realised I had found my soul purpose, the reason I had been put on the earth for, and in the process I had found me, the real me.

I also received meditations, lots of them, they just didn't stop, most of my automatic writing takes place at night as it seems easier somehow without the noise and interference of all the electrical devices. But amazingly, whenever they have had me up writing, no matter how little sleep I get, I always wake up feeling refreshed. I even recorded my meditations on to CDs and sell them online.

Whilst I was growing up, I always had knowledge that there was more to this life than what we could see, but I did not have the understanding to go with it, which is often the case with children. I know I often saw lots more people than others could see in a room, but I sort of knew they were not as real as you and I. I saw far more as a child than I do now, but I am comfortable with that as I understand you don't only have to see Angels and Spirit to experience them. Just as you don't have to see a virus to know you have one, you can feel that without any doubt. So I am hoping by reading this book you too will learn your Angels are with you and you are not alone.

Chapter 3
All about Angels

"Your Angels are redundant until you give them something to do".

We all have Guardian Angels and have had them from the start of our life, and they will be with us until we pass over. No matter what you do, or however much you ignore them, they will still be there giving you signs. I tend to imagine them sat "Upstairs" in a nice big chair, tossing down feathers and other signs, looking down at our lives unfolding, shaking their heads thinking, "We could have helped with that, if only you had asked". They are just waiting for an opportunity to help, but can't help unless they are asked, they need permission to intervene.

One of the many wonderful things about Angels is they will always communicate with you exactly how you need it, the way you can understand. This means you can become your own expert on your own Angel.

It can become a deeply personal relationship which, like all other relationships – the more you put in to it, the more you get out of it, and I am living proof of that. I like things to be simple and uncomplicated, after all life can be complicated enough, and my Angels understand that is what I need, so their communication, signs and names they use are all with that in mind.

Everyone has at least one Guardian Angel and they are with you all the time. But sadly, they are often twiddling their thumbs or sat "Upstairs" doing their knitting! But even so, they are most definitely watching your life unfold, although frustrated in the fact that they can't help you unless you ask. It is a crazy rule, but it is the law of free will.

There is, however, one exception to the rule, that is they may intervene and save the day if it is not your time to pass. Like the day when one of my workshop attendees was travelling to Manchester alone in her car and she heard someone shout "slow down". Slightly taken aback, she did slow down and pulled into the first lane of the motorway, where her tyre blew! She was able to pull over onto the hard shoulder, but it doesn't bear thinking about if she had still been travelling faster in the overtaking lane.

A few years ago my son and I came across a road traffic accident. It was the middle of winter and the roads were icy. We were travelling home on a quiet

lane and the car in front came to a stop just on a bend. We couldn't see why, but pulled over too; next thing, some lads appeared from around the corner and seemed really distressed, so we got out of the car to help and we could see one was holding a cut arm. Immediately as we got out the car you could just sense the Angel presence that was there, I can only describe it as a calmness and stillness, almost slow motion. I could see around the bend by then and the car they had been travelling in was upside down with the driver compartment totally squashed. They had all climbed out and apart from a few scratches and torn clothing were all unhurt. None of them could understand how they got out alive, but I knew the Angels had saved their lives; it was simply not their time to pass. As the police arrived I made my way back to my car, but just mentioned to them they were very lucky and their Angels had certainly been looking after them. These three burly lads all agreed something had saved them, that was for sure.

Angels are messengers from Source, whoever you believe that to be. They are one of the few things that all religions agree on. Like everything, they are energy, they are neither male nor female, though personally I like to refer to them as hes. They are not concerned about a name, that is something they understand we like, so therefore use a name for just us if we ask. They will also appear and communicate in the way each

individual needs it. So they can even personalise it for us. Hence they are your personal Guardian Angels – you don't share them with anyone else.

As I mentioned earlier, I don't see Angels or Spirit like I used to when I was younger, but I do see Angels as lights, shadows or even a colour. In my bedroom I have my Angel altar, it is a place I can sit, light a candle and connect in with meditation. Angels are very clear that we should not worship them, but it is polite to use manners, this also speeds things up when we are asking for something.

Often we are experiencing signs, but we put them down to something else. I often see sparkly lights out of the corners of my eyes, which I know are Angels, and I find it very comforting. But I woke up one night to see not just one sparkly light, but what looked like about eight all together. I have also seen a large glowing shadow shape of an Angel on my bedroom door. When I do see these sorts of things it gives me comfort that they are there. In my experience Angels are never frightening, and if you are ever feeling nervous, scared or worried they will be there in an instant to take away that nervous feeling if you ask them.

Angels can appear in many forms, some people have seen Angels in flowing gowns and with wings that may appear for example at the bottom of the bed. They can also appear and look just like a real person, but

generally their feet won't touch the ground. They may appear just from nowhere and disappear the same way, but perhaps leave you with some words you needed to hear. Of course, there is the real life earth Angels, e.g. you go shopping and end up seeing a fabulous new TV which is an absolute bargain. You decide it is an offer you cannot miss, so you make your purchase and the shop assistants help you load it into your car. But what happens when you get home, how are you going to get that into your house? You ask the Angels to help you, now they are not likely to float down and give you an actual hand, but you may find that next thing you know a neighbour comes along and says "Do you want a hand with that?" "The Upstairs" can organise help in that way, so it may not always be a shadow or lights that you experience when asking for help, they may send you a physical person.

I want you to realise that even though I work with Angels every day, I do not physically see them like you might think, but that does not worry me and don't let it worry you or stop you from working with yours. One day, when I was still working in my shop a lady came in that had been on my one of my workshops. She re-told this wonderful story about her experience of seeing an Angel.

She was in another shop talking with a lady when this incredibly gorgeous man appeared from nowhere.

He chatted with them and gave them the answer they needed, then disappeared out of the shop and just vanished up the street. She knew he was an Angel as when she looked at his feet they didn't touch the floor and you could see through his toe caps!

Another story I love, also happened in my shop. Chatting one day with a customer called Tracey, I was just explaining how a lady had come into my shop quite distressed and felt she needed a reading but couldn't afford one. I told her not to worry, I would give her one anyway. Just as I said this, Tracey suddenly burst into tears. She told me that there was an almighty big Angel stood right behind me, he was so big his head looked like it was going through the ceiling and he was wearing a colour she couldn't describe as she had never seen it before. I turned around but could not see what she was seeing, but nevertheless I am sure he was there as I could feel warmth on my back. Even as I type this story I get the tingles of goose bumps which are always confirmation for me.

Sometimes Angels can appear in your photographs as orbs. First time I saw one it resembled what I can only describe as a blob as if maybe some liquid had been dropped onto the photo. But now I have many photos all with wonderful Angel orbs on them, in fact, at my son's birthday party some years ago we hired a sports hall and he had his party there. There were 20

plus children all running around, skidding and crashing into each other and just like most kids filled with excitement of the party, they all seemed hyperactive even before they had been given the party goodies.

My daughter who is older was sat at the side taking pictures throughout the whole party. I was feeling rather anxious that someone was going to get hurt with all this running around. So, of course, I asked the Angels to help and keep everyone safe. I have got to say that the children didn't calm down; they had great fun playing all the games. But there were no injuries, even with all the bumping and crashing into each other no one got hurt. Later that night, when we were looking at the photographs my daughter had taken at the start of the party, there were no orbs on the photos, but then, after the time I had asked the Angels to keep everyone safe the photos had orbs all over them. I couldn't believe it, it was amazing, and the Angels actually showed themselves on all the photos. I was so shocked the next day I went back to the sports hall to check the lights – maybe they could have reflected and caused these magical blobs all over the photos. But no, the type of lighting used could not have put random blobs all over the pictures, but the Angels were just giving me some more evidence they were there.

Of all the Angel stories I have heard and that I have experienced, one thing I am sure of is they are not scary, but comforting, reassuring and make you feel loved or give you a warm glow. So just because you are not seeing them fully as some may does not mean they are not with you now as we are never alone.

Because the Angels are with you all the time, nothing you do, say or think will come as a surprise to them; they already know you inside out! So you never need to feel alone or that you have no one to talk to as you have your Angels. You can tell your Angel honestly how you feel, really pour your heart out without fear of being judged. Your Angels want you to give them your problems and all your concerns, when you do you will find that you can cope more easily. This must not be confused with the thought that you will have no more problems as that is often how we learn, but your ability to cope will be far greater.

Many people ask if their loved ones are Angels? I have no problem if that's how people want to view it as it can offer comfort to some, but Angels have a higher vibrational energy than Spirit and have not been on the earth. A Spirit is a person who has been on Earth and they can also act as your Spirit Guide. They do not interfere with your decisions, but simply guide and give general advice and support. They can be loved ones who have already passed over and because of

this they feel more familiar and come through with the same personality as they would have done when they were here. So if Great Uncle Bernard was grumpy when he was here, the likelihood is he still will be, but at least you will be able to recognise him! Though most mellow and have a greater understanding of life since their passing. They also may have even passed over before you were born. Spirit Guides can change throughout your life and it may even be someone you don't know, but they have the expertise of whatever you are dealing with at the time.

There are a couple of questions people always seem to want to know, the first one is – "Is my loved one ok since passing?" I have to say over the years of connecting with Spirit, not once have I had one come through and say it is horrid. There is no pain, worry or heartache; I guess you could call it heaven.

The other question I am asked over and over again, is – "Can they give you the lottery numbers?" Working with Angels feels to me like I have won the lottery, all their support is amazing and they have certainly brought me good fortune too! By this I don't mean swag bags of cash, but they will always take care of me and will take care of you too.

Abundance to the Angels is not how much money you have in your bank, but who and what you have around you, including your health. So as far as they

are concerned, as long as you have what you need to survive your needs are met. They do, however, teach us very important lessons about abundance, which is not how much money you have in the bank. Often, as humans, we don't realise what we had until we have lost it, but when you work with your Angels they help you appreciate what you have now.

As well as having your own personal Guardian Angel, there are lots of others Angels too. You can ask these to help you whenever you need extra help, there are no limitations, just ask for as many as you need.

Children often see images of Angels and Spirit as they are growing up, I know I did. Sometimes they even refer to them as their invisible friends. It is easier to see Angels and Spirit as a child as we are far more accepting and don't have the complications of life that we have as adults. But with work you can see them if you want to.

As you develop your relationship with your Angels, you may start to see sparkles of light out of the corner of your eyes as often these are the first things you see when you become aware of Angels. They are the Angels' trails as they move about, lots of people see them. If you don't already see them, you will probably start to see them as you develop spirituality, but just remember your Angel will give you the signs you need, so you might be more open to feathers.

Angels hear every thought, emotion or wish, but remember they can't help you unless you ask. When you ask they will always answer you even if you don't feel it initially. We just have to trust and believe, and I know this is not always easy but you have nothing to lose by trying.

The key to working with Angels is to open your heart and your mind to the magic of Angels and then you can receive support and blessings beyond your wildest dreams!

Chapter 4
Angel signs

When is a sign, a sign, and what does it mean?

Your Guardian Angel, and you can have more than one, has been around you since day one, giving you signs to let you know they are there for you.

But because we all have busy lives we can easily miss their subtle signs. They often use everyday items as a way of communicating and, as you start asking for

the help you need and working with your Angels more often, the signs they are giving you start to come into your awareness easier.

But understanding it is a sign and what it means can take some working out. The main thing is, it is your sign and what it means to you is the important bit, not what it means to someone else or by looking it up in a book. Your sign, is your message from your Guardian Angel, remember your Angel will communicate exactly how you need it.

Generally, they may be reminders that they are giving us to let us know they are around, and to remember to use them for help where needed. Or it may be a little message that whatever you are concerned about is going to be ok, so not to worry. But as your relationship develops you will come to understand what they mean and be able recognise their signs at a glance. I would suggest though whatever the sign is, when working out its meaning use your intuition. That means go with what initially it feels to you within that instant, rather than thinking and pondering over it. Your intuition is immediate and happens before you start to rationalize the thought.

By far the most popular signs are white feathers; they are often called 'Angel Calling Cards', once you are aware of these they turn up in the most random of places. When I have been doing readings, I have

little tiny ones fall between the client and myself, even though the room and furnishings have no feathers in them.

I find it very comforting when I see the white feathers, they always make me smile. Some people like to collect them in a special box but I like to just acknowledge and say thank you for the sign. Sometimes, you don't just get one, but lots and lots, far too many to put in a box, and this is exactly what happened to me when we went to view the house we ended up living in. You would have thought there had been a dead bird with the amount of white feathers covering the garden, but no there wasn't! It was a sign that it was the right place for us to live and believe me they were not going to let me miss their message.

I am very thankful for their confirmation as I could have been initially put off by the fact it was out of my budget, but they knew it was where I needed to be. It ended up being two houses – we lived in one and my parents in the other, therefore making it affordable. The Angels certainly guided me to the right house and we have never been happier living anywhere, we all loved the house immediately. It felt like home as soon as we walked in, and it led to me feeling confident to say "yes" when I was asked to be a contestant on ITV's "May The Best House Win" too.

Another sign is that you may get goose bumps

and tingles, this for me is a sign of confirmation that something is right. Some people feel a breeze or air pressure changes too and take that as their sign from their Angels.

Angels often tickle you with their feathers. It feels as if someone is softly touching your hair, or as if a little spider is crawling on you, or you have just walked through a spider's web. They are just letting you know they are with you. Ironically, as I wrote this line I got one on my chin!

Angels can hug you, they wrap their wings around and you may even get a tickle of their feathers then too. When they do this you may get a warm or perhaps a really comfortable feeling. You can do this in meditation or just as easy by sitting quietly and asking your Angel to come in close, you may just get a tingly feeling or even just a knowingness they are with you.

Angels work with all senses, so you may notice a beautiful fragrance from nowhere – again just be reassured they are around and watching over you. It may be the perfume of a deceased love one or a smell you like. One of my clients always smells gingerbread, this is a smell she remembers from childhood and she finds it comforting.

Angels will give you many signs that you can just see right before you. Sometimes a butterfly or little bird like a robin coming really close. One day my daughter had

been taken ill and was in hospital. As for any parent, it was a worrying time. But as I went to open the curtain on the window sill there was not just one but two butterflies that didn't just fly away – they stayed reassuring me all was going to be ok.

Rainbows not only brighten the sky on a rainy day, but again can be another sign of your Angels. A few years after my Nana's passing I was asked to go and do some readings in a local nursing home. I found it quite a difficult day, not because of the readings, but because of returning to such an environment. It brought back a lot of memories of Nana. Even more ironically, when I arrived there one of the ladies looked just like my Nana – when she smiled it was like my Nana smiling at me. I did the readings and I managed to hold it all together until I got back into my car, and on the journey home the tears of sadness flowed. My chest hurt with the pain just like it did on the night she passed. I missed her hugs and her no longer being on the earth plane, strange even though I still talk to her in Spirit. I pulled the car over as I could no longer see to drive. I called in my Angels to help, and as I wiped the tears away I looked up and saw a beautiful, bright rainbow, not just curved, it was a straight bolt coming from between the clouds. I knew this was the Angels easing my pain, distracting me with the strange shape of the rainbow and again giving me a sign I was not alone.

Pictures within the clouds is not only a fun thing to look out for but can be a significant sign from your Angels too. Some people may see Angel wings or other shapes that mean something to them and they understand this to be their sign.

But one of my favourite signs is synchronicities. This is experiencing the same things in twos or threes. It may be noticing the same numbers in registrations, clocks or telephone numbers on sign boards. Maybe you keep waking at the same time on the clock. Or, hearing the same sentence said by different people, making your ears prick up. Or even the same song on the radio. Some may say it is a coincidence, I don't believe they exist; I prefer to call it Angel Magic. Here are some examples:

I was travelling to drop my son off somewhere, I had no concerns or worries, no problems or decisions I needed to make, but I heard a song on the radio that stuck in my head when I was travelling up the bypass. I also noticed a vehicle that was the same as mine but with a sign written for a satellite company. I didn't think anything of it until I was returning to pick him up and I heard the same song on the radio on the same bit of bypass, and saw the same vehicle I had seen earlier in the same place. What were the chances of that happening as it was about 6 hours apart in time. I knew it was my Angels just saying "Hi" and reassuring

me they are always there. It is just about us being alert for their signs.

I was trying to decide whether to take part in ITV's, "May The Best House Win". I knew because the TV company had contacted me direct the Angels would have had a part to play in organising that, and I have come to learn that they have my best interest at heart. So it must have been right to do it, but even so I still wanted extra confirmation. I decided to ask to see some Angel Magic! More specifically, I asked to see something in "threes". I was in the middle of a shopping trip with my daughter at the time when I got the call, so it goes to prove you can communicate wherever you are and whatever you are doing. It does not have to be a big ceremony or meditation, but just as you go about your life. So I asked the Angels to give me a sign in threes if it was right for me to go on the show. The next thing, a taxi drew up with the telephone number 83 83 83 on the side of it! That was the confirmation I needed and I agreed to take part in the show.

Another example I love is relating to our wonderful home, where the garden was covered in white feathers. I had been frantically searching for somewhere new to live as we were coming to the end of our rental period in the last house. I was really starting to panic to find somewhere new and nothing seemed suitable. The children and I had three weeks left in the house before

we had to leave. So, I sat down and had a serious talk with "The Upstairs" as to what was in store for me. I told them by the end of that week they must find me somewhere to settle as I didn't want to keep moving. In the space of 24 hours 3 people came into my shop and said "have you seen the house near the golf course." After hearing this three times, my ears pricked up, so I searched it out on the Internet and realised it was the house I had seen numerous times before, but knew it was too expensive for me. It would have been easy to dismiss this house, but this was a message, so I knew I had to take a proper look and made an appointment to view the next day. As I mentioned earlier it was covered in white feathers in the garden, so it is safe to say the Angels definitely had a part to play in us living there. They not only made sure I went to view it by getting other people to keep mentioning it, but then covered the garden in feathers so I couldn't help but notice – it was like they were screaming at me "live here". It became really clear when we went inside that it was two properties. My parents were looking for something new at the time, so they took one part and us the other.

Sometimes we hear signs and messages from our Angels. Often when we are developing our relationship with our Angels we may get a high pitched buzzing in one of your ears or for me it is a clicking noise. This can be a little strange and you can be forgiven for thinking

you have an inner ear infection or are possibly starting with tinnitus! But it is when they are re-tuning us, or trying to get our attention. When you are developed enough to hear them or their signs they are giving you, you may even hear Angelic music playing from nowhere or you might be lucky enough to hear their voices. This might be a whisper, shout of warning, or a voice counselling you inside your head. I can't blame you if at first you think you are talking to yourself, but you will soon learn that they are their words not yours because they will be different in tone or just different to the choice of words you would naturally use.

Angels often communicate via music, and one day I was travelling down to Bolton to do an Angel party. As my family will tell you, I am really good at getting lost – even with satellite navigation! They always know we are lost when I say "I have a rough idea where I am going". But this particular day, I had asked for help from "The Upstairs". I had asked for us to arrive on time and not get lost. Sure enough, when I turned the radio on a song was playing and some of the words were "the Angels are leading the way". I knew instantly they were guiding me, needless to say I didn't get lost and I got there on time. So next time you put the radio on or walk into a shop, listen to the words and see if there is a message in the song for you.

Almost everyone will first experience "The Upstairs"

with clairsentience, which is a feeling, or claircognizance which is a knowing. Some might call it your gut instinct or sixth sense. It is important to trust that what you are experiencing is the Angels trying to communicate to help you.

Remember you are unlikely to get all types of communication, maybe a few or just one sign, and their signs may change as you develop your relationship with them.

Please don't think that I am a person who gets it right all the time, never misses an Angel sign and always does what they say all the time... as I am far from that. We are all human, we are not meant to be Angels and we do get it wrong sometimes.

Every day, first thing in the morning as I do my grounding and protection exercises, I check in with the Angels and thank them for keeping us all safe overnight. I also ask what am I to do today? Normally they guide me to an important job that needs my attention, this may be that I need to contact someone in particular. Or it might be giving me advice to look after myself, or maybe spend some time with a friend in need. But one day, when I checked in with them they told me to do nothing. I couldn't understand it and I certainly was not going to listen to that. So I got on with my day and decided I would work from home to get my meditations ready for going to the studio to record

them. So I was pottering on with my day and taking my children to school, on the way there we heard the local radio station play the McDonalds advert at the junction at the end of my lane. I dropped the children off and returned home, again at the same junction, the same McDonalds ad came on again. I just smiled and thought "Angel Magic" synchronicities. Then, as I looked up, there was a field with only three sheep in it and they were all facing the same way standing diagonally in a line. Strange, I thought, but definitely knew it was the Angels again, trying to get my attention. But I was not going to do nothing like they said, I had work I needed to do.

So, once I arrived home I got on with my work on the computer, but it was just not happening. I could not seem to get anything right; it was like my brain was frozen. Then I heard a bang as if a bird had hit the window, looking around I found it had, but it was inside my living room not outside! Now, I had a little robin flying around my living room and making a mess all over my sofa! I couldn't believe what I was seeing as it was a total mystery how it got in as there were no windows or doors open. We have a chimney, so I thought it must have come down but that would have caused a soot fall and the fireplace was clear, so that clearly was not the way it got in. To this day, I still don't know how it had got in there, but I was sure the Angels were trying to communicate but I was just not

listening. After I had recovered from the shock of the robin flying around my living room, I asked the Angels to help me get it out. I needed their help as I am not brave with birds, especially ones in my house. So, I asked the Angels to make the bird fly over the other side of the room where the kitchen was so I could go and open the door then it could fly out. As soon as I had asked it flew over and sat on my washing up liquid bottle. I opened the door and asked the Angels to make it fly out, which within seconds it did. I have to say I was relieved and amazed how easy it was to get the robin out with my Angel's help.

I realised it was time to listen to what they had said and I turned my computer off, only to find my grand-parents were coming for a visit. If only I had listened in the start, I was not to do any work today,

I am giving you this example as I really want you to know they use everyday things to communicate to you.

When you are fully connected with your Angels ,things in life just seem to slot into place. A lady came for a reading, she knew there were Angels but not how to connect and what to watch out for. After the reading she felt uplifted and was given a sense of hope as she had been having a difficult time due to her husband's passing. She then realised she had been receiving signs but did not realise it, as to those who are not 'in

the know' they would seem just like everyday things that we see daily.

We all can experience this for ourselves just like the lady whose husband had passed over. She came back in to see me a week later; she was like a totally different person. It was wonderful to see her, she was bouncing, full of energy, far different than the lady I had seen the week prior with low mood and putting a false smile on her face, this time her smile was genuine.

She had given her Angels a chance and they had delivered, giving her the comfort and support that she needed. The signs she had been receiving she was now able to understand. She had even been asking the Angels for help with lots of little things and they had fulfilled her wishes, with parking spaces, a table at a restaurant that was usually reservations only, an impromptu visit from her daughter, even help for her granddaughter with some difficulties she was facing.

It is easy to miss signs as they are using everyday things, but we need to pay attention and sometimes slow down with life, so as not to miss them.

As your relationship with your Angels grows, you will start to connect and understand the messages that are coming through for you and recognise the signs you are being given. This can really impact on your life as it is a truly special feeling. The love of Angels is like nothing else you will have experienced before. It is not

floaty, fluffy and conditional. It is gentle, but makes me feel strong, very supported, cared for and loved un-conditionally. When you allow the love of the Angels into your life, it grows and allows you to love yourself as you are, your life as it is, and others without needing them to change. They help you to be more tolerant, compassionate and very importantly, realise what is really important in life and what isn't. Your values may change and you start to feel more content with your life and find the direction you have always been seeking.

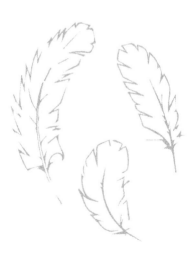

Chapter 5

Angel communication

How to ask for help

The Angels are sat up there waiting to have the opportunity to help you, to guide you along and make things go smoother. That's just what happens when you ask them, things just slot in to place. But one of the questions I get asked is, "How exactly do you ask for help?"

There are no hard and fast rules with Angels. As I have explained it is not something complicated and they will always personalise their communication to your needs. It is the same when you ask them for help, they are not bothered if you talk in your head, like you are praying, write it down or even

shout it out as long as you say "Angels" and ask for the help you need.

They are with you before you have even finished saying the word "Angels".

It is however, important to use manners, so saying please and thank you is paramount. Also, strangely enough, saying thank you for something you have not yet received seems to speed up its arrival!

As you develop your relationship it is also nice to make Angel communication part of your daily life instead of just asking when you are having a problem. I personally have a chat first thing in the morning and last thing at night, plus numerous times through the day.

My preferred way of communicating is just by talking in my head to them. Of course I have been working with them a long time now and I also hear their replies. But it is the same as all relationships, the more you put into it the more you will get out of it, and you will soon start noticing the Angels around you all day long as your relationship becomes stronger.

You may wonder what I chat to the Angels about. Well this is the time I give thanks for my blessings, thank them for what they have already done for me, or sometimes to un-burden myself without fear of being judged. I am not going to surprise them as they have watched my life unfold to date, but it is wonderful

to know that you always have someone to talk to. Everyone finds their own best time and place that is right for them; some I know do it in the shower or on the way to work. But I like to do it last thing at night and first thing in the morning.

What can we ask Angels to help with?

To answer what Angels can help you with, it is probably easier to say what they can't help you with because they really can help you with everything.

You can ask your Angels to help you with anything you would like help with. I also like to ask for others too because I would feel selfish if I just asked for me all the time. So if I have a friend in need or hear of some terrible tragedy on the news I ask for the Angels to help where they can. As I am going about my day, if I see a situation like a little child misbehaving for their parents, I ask again for the Angels to help both the child and the parent.

Angels can help with all aspects of life; you can come to see them as your first point of call. I would encourage you to start with something small, but really there are no rules. I generally recommend people to try with a parking space as they are wonderful with them. When you set off on your journey ask for the space you will require, then relax and continue on with your journey knowing the Angels will be taking care of your request.

Don't keep asking, you only need to ask once. They will never let you down.

They not only help you with parking space but keeping you safe when driving. I always ask the Angels to help me get out of a junction safely or not to get held up in traffic jams, and traffic lights to be on green.

One morning, when I was driving the children to school, we were on the last minute as usual and it was the most dreadful wet morning. It was really tipping it down and the wind was wild, anyone would have thought it was the middle of winter, not May. So, I was travelling along going faster than I should trying to make up some time, when I heard "Put both hands on the wheel and slow down". I didn't need telling twice, I knew it was my Geoff talking to me, and I am terrible for driving with just one hand on the steering wheel. I immediately gripped the steering wheel with two hands and took my foot off the pedal. As we went round the next bend the road was blocked with a council wagon unblocking the drain which was overflowing with the rainwater. The road was flooded and had bollards across it. If I hadn't have slowed down I would have not stopped in time, and goodness knows what the outcome would have been then. I just said out loud "thank you". The children asked who I was talking to. So, I explained that the Angels had just possibly saved us from a nasty accident.

The Angels are out and about with us all the time and one of my clients, Jill Turner, had an amazing Angel encounter whilst on the M6 motorway. She was travelling along on the journey home; it had been a long tiring day, emotionally draining as she had been delivering Christmas presents and tending to her parents' grave. She was tired and she could feel someone sat next to her in the passenger seat, but she knew she was travelling alone. She turned to see a most beautiful Angel sat next to her, she was not shocked, scared or distracted but felt comforted, safe and she knew the Angel was there to get her home safely and indeed she did.

Angels can help with lots of problems that occur in life, from love life problems to practical things such as fixing engines or computers. I know, I ask all the time for the right words with a difficult conversation, or if I don't know how to do something on the computer I just ask for their help, next thing I have found the solution! It really is as easy as that.

They can help bring the right people into your life or help dissolve problem relationships. They help with family life and difficult situations of any kind. Try them next time your children are having a squabble – ask the Angels to help them stop and try to see things from each other's points of view. You can also ask them to protect your children or family, imagine them surrounded in a white bubble.

The Angels can also heal emotionally, mentally and physically. If I ever have a pain, I always ask them to remove it for me. They can help you heal from difficult emotional problems as they give you strength. They are wonderful and helping with forgiveness both with yourself and others. They understand that if we do not forgive it leaves a bitterness inside which is damaging to us.

Often when you need physical healing they may guide to alternative practices, i.e. you may notice a sign for Reiki master or reflexologist that you feel drawn to trying. But I also know others that believe they have been healed from dreadful diseases by the Angels.

They can help you with your career, they may guide you to the correct place for your education, or bring a different newspaper to your attention with the ideal job advertised that is waiting for you. They want to help you with your spiritual path and if you ask, they will guide you to your soul purpose, the reason you were put on the earth for.

Sometimes, if you are shopping for something special but you can't think where to go for it, ask the Angels and you may find that the right place just pops into your head. Or someone may come along and mention the right shop to you in passing.

One thing that I find works especially well, is asking

the Angels when you lose something. They are great at finding lost keys, missing paperwork etc. So next time an item goes astray, ask if they can help you find it. Once I have asked for their help in finding it, I generally get a feeling to look in a certain place, and lo and behold I usually find it just there.

As I have mentioned, I continually talk throughout the day to them, asking for little things to help my day go easier. Such as when it is icy, I ask that I don't slip over. I recently have had to do a lot of IT projects and I am not good with that sort of thing, but they helped me find the Copyright button when I had no idea how to find it. Again, I just asked, and the next thing, I got a feeling to try something and the answer appeared.

One of my favourite things to ask for is a good night's sleep, but I always add to the end of that sentence, and to wake up feeling refreshed. Then, even if I do get disturbed for any reason, I still can cope with the day ahead.

I think the most difficult bit is actually remembering to ask as it is very easy to get wrapped up in our problems and struggle to sort them out in a normal way. For instance, if your computer will not print, after checking all the obvious cables and connections, give the Angels a chance before calling a repair man, they may save you some money. I look upon them as my first emergency service!

But a word of warning is – keep it realistic, don't be asking for the day to be twice as long so you can get everything done. They will not provide you with unrealistic things. You could ask for help to get everything done and they may well send someone along to give you a hand.

They work for the highest good of all. So you can't ask for something good for you that has a negative or bad effect on someone else. After all, they are Angels and want everyone to benefit from them. They will, however, provide you with the money you need as long as you are not being greedy, but are more likely to allow you an opportunity to earn it yourself.

Sometimes we ask for things we don't actually need. I am guilty of this. It was coming up to my daughter's 17th birthday and I had always said I would get both my children a car each for their 17th. As I had always imagined I would be able to afford it somehow. But the birthday loomed and I certainly did not have any spare money for a car. I kept asking for more money and I honestly thought they would have made me busier with my work so I could have maybe taken out some finance to afford one, but nothing changed. So, during a meditation, I asked why and they said I already had it. I really didn't understand what they meant as I knew for a fact that I did not have any spare money. But I did get a feeling to go and look in an old filing box at the back of a cupboard, there I found a folder which had

my daughter's name on it. I opened it up and couldn't believe that there was a policy that had been started when she was a baby, and it had enough money in to buy the car. I had totally forgotten about it and it was just shoved to the back of this box. So no wonder they didn't fulfil my request because I didn't actually need it – I already had it.

I would also urge you to be really specific about your request, including the timeframe you want it done by – if you say you want to find a new job by summer, *which summer do you mean?*

The rented house we live in is a wonderful place to live, but incredibly cold. We had been talking to the landlord about central heating and I was hoping they were going to agree and we would be warm for Christmas. So I thought I would just help the situation along by asking the Angels for the same thing. I said "Please can we be warm for Christmas" after all they know everything that is going on, so they would understand I wanted some central heating. Well, this is not exactly what happened. I was warm for Christmas, in fact, we all were as we had a very mild unseasonal weather, but sadly no central heating.

So keep it clear and precise and then there is no room for mistakes. Plus, of course for the highest good of all concerned, don't forget, only ask once, don't keep repeating the request.

What do the Angels really give you?

As well as giving you help when you need it, the Angels will give you so much more when you truly work with them daily. They give you a greater sense of peace, you feel less irritated and more tolerant of others, you feel happier, supported and loved, and just overall more content with your life as it is now. They are wonderful at making you realise how blessed we are, as we often don't realise what is right under our noses. They help you realise that it is important to be happy today with what we have, rather than thinking I will be happy when e.g. I change my job, or meet a new partner. So we don't live in the past or always look to the future, but live for today. After all, life is a gift, that's why it is called the present.

I would encourage you to work on a practical level with your Angels at first, asking for the parking space and moving on. It is so wonderful when you first realise you can create what you need with the help of the Angels. Seeing it materialise right in front of your eyes allows you to start to trust they are there and wanting to help you. Then, as your relationship grows you will realise the support and love they give you is like nothing you will have experienced before, because it is much deeper and coming from a place of love, un-conditional love.

Personally, I have never felt alone since working with Angels even though I have not been in a relationship for many years. Though I do find myself using the word 'we' all the time. So when someone asks me to go somewhere, I often say "yes we will come". Even though I know it is only me in physical form, there will be many Angels coming along for the ride.

One thing I really want to make clear is that Angels will not take all your problems away, and I am not saying my life has been without problems since I have been working with my Angels (life is not meant to be like that). We have come here to learn, for our soul to grow and develop, and that is often when we face problems. But how you cope, the strength you receive is much greater with the support and help from the Angels, and we all need a little bit of support and guidance sometimes.

The most amazing thing about the Angels is they love you 100% no matter what. They understand we are not perfect as they are the Angels, not us. But they still love us no matter what you have done, thought or said, and there are no secrets as they have always been with you. They still love you unconditionally and that makes it a very special relationship. They want you to be the best you can and want you to love yourself unconditionally too. They understand you have made mistakes but overlook them, and importantly try and help you learn from them.

When you try and see yourself and others through the eyes of the Angels, you will experience life in a whole new way. Even when people have annoyed or upset me, I put my Angel glasses on (it is an imaginary pair). This helps me see things clearer and from other people's points of view.

Please remember, you can ask the Angels to help you by thought, words or written letter. You can even ask as many Angels as you like. But they are not to be worshipped as that is for 'source', whoever you believe that to be.

Chapter 6

How to develop your relationship with your Guardian Angel

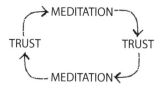

There is nothing scary about connecting with your Angels. You are not opening yourself up to attract some bad spirits, it can only have a positive effect on you.

It is a good idea, however, to be grounded and protected just in life in general. There is not enough said about the importance of grounding and protection, as it is good practice to use in daily life even if you are not working with Angels and Spirit. After all, we are all energies and susceptible to other people's energy, so we can be affected by them even as we walk down the street or go to a supermarket. I am sure we can all think of someone whose energy drains or affects us.

Life can be difficult enough without being drained by others, so please give these simple visualisation exercises a go as they can really make a difference.

Meditation and **trust** are the key things in developing this special relationship with your Guardian Angel. When we meditate we quiet our busy mind, so we can receive things we wouldn't normally do when we are rushing around with our busy lives.

To understand the different realms of "The Upstairs", think of each different spiritual plane in layers.

The reason I want to explain this is because, often when we are trying to connect with Angels through meditation, we may not go quite as far up as we need and we may meet a loved one that has passed over or a Spirit Guide. They have very different roles than an Angel.

Layer Three
Angel realms

Layer Two
Spirit, these are the loved ones that have
passed over and our Spirit Guides, helpers etc.

Layer One (at the bottom)
This is us, on the earth plane.

It does continue up with more layers until we get to
source, but for this understanding this is all we need.
Angels always deliver with love. They make us feel
warm, safe and protected. Angels will never give you
something you can't handle.

Grounding and protection exercises, ideally these
should be done daily, but they do not need to be very
long. The ones I do are just short visualisations. They
work on the principle that, as long as you believe in
them, they will work for you.

They are, of course, a great time in our busy lives – to
have a couple of minutes to yourself, just tuning in to
you. We all go so fast and often ignore what is going
on internally for us, so this is a good time to check in
with yourself.

It is about getting into a routine and making it fit in
around your daily life, that way it does not feel like a
chore.

I like to do my grounding and protection exercises before I even get out of bed. After all, with two teenagers in the house, their energy (not to mention moods) can really start your day off badly if you absorb them.

Not being correctly grounded can make you feel physically unwell, giving you a host of symptoms such as feeling dizzy, daydreamy or 'spaced out' feeling. Eating is often a good way of clearing these symptoms and I would certainly recommended having something to eat or drink if you still feel floaty after a meditation – that will bring you back fully grounded in no time.

I am sure you can all bring someone to mind who you may consider ungrounded. They probably seem as if they are literally floating through life. They are so into their beliefs and visions that they seem to have their heads in the clouds. When they speak they have trouble making sense as they are so involved in other experiences. They often seem a bit scatty and have good intentions, but never seem to do what they say. Being ungrounded makes life more complicated than it needs to be and the reality is we have to live on the earth plane whether we like it or not. So we should not underestimate the importance of being grounded.

Protection and Grounding Exercises

Protection exercise: Imagine putting on a thick cloak, it covers your whole body from the tips of your toes right over your head with a big hood. It even has a veil that drop down over your face, making sure you are totally protected. Inside the cloak it is warm and cosy. Outside it is reflective and all negative energies just bounce off it and reflect back to the person who owns them. It can be any colour you like and you may find it changes colour depending on your mood.

Grounding exercise: Sit or imagine you are sat in a chair with your feet flat on the ground. Imagine roots growing out of your feet down into the ground, going deeper and deeper like tree roots. Once you are well grounded, imagine with every breathe you breath in from your roots, white light moves up your body, higher and higher, filling the inside of your body with beautiful white light. When you get to your head, the white light starts to come out of your nose and mouth and surrounds you in a bubble.

These exercises don't need to take long, but I am sure you will soon experience their benefits.

Meditation

People often ask how they can develop themselves psychically? The answer to this is to **meditate**. It is a way of quietening our busy minds, accessing our subconscious. In fact, there are many benefits from **meditating**, such as helping with stress and relaxing and also for managing pain. But it is not always easy to do because we have busy heads, so it requires practice, and it is something you need to stick at but worthwhile as the benefits it gives are enormous. I personally love to meditate as I get the answers to questions I have; I like to think of it as direct dial to "The Upstairs".

Finding the right time to meditate is important; some people like to **meditate** first thing in the morning or maybe last thing at night. Try different times to see when is best for you.

Someone once said to me they **meditate** for one hour every day and it is the most important hour of the day. I would agree that it is a very important time, but honestly, I do not have one hour a day free to give to meditation alone, so all my daily **meditations** are short, but they give me focus for the day ahead.

You can **meditate** in lots of ways; by walking, or in your own head with your own meditation routine, focusing on your breath, by concentrating on a flame of a candle, or even by just holding a thought.

Though often when we first learn to **meditate** it

is easier to follow a guided **meditation** such as my Mystic Moon's Angel Awareness.

To meditate, it is a good idea to be in a quiet, comfortable place without interruptions (if possible)!

At first, don't lie down as you probably will go to sleep, but a blanket is useful to keep you warm.

Keep your arms unfolded to help the energy flow and take off restrictive and tight clothing.

When you find yourself drifting off thinking about other things, just bring yourself back to the meditation. It does not matter how many times you have to do this when you are learning to meditate, but this is the important bit where many end up giving up.

Often people think they are just going to sleep, even if that is the case it is what you needed so stick with it; because that is what you needed at the time and you still will have done what you needed to.

But please, never try to do it whilst driving. I had a friend who once arrived at my house and seemed to float through the door. She had driven to see me whilst doing a guided **meditation**. (Not one of mine I hasten to add!) How she got here in one piece I do not know, the Angels must have been really looking after her that day.

The other question I am asked a lot is where did I learn all about Angels, did I have any special training? The answer is "no" I didn't go anywhere like that. But I learnt all my information from the same place all the other spiritual teachers did – "The Upstairs"! You can do this too if you want as we all have the same direct dial number to them, it is **meditation**.

I believe there is only one teacher and that is "The Upstairs", should we require or want to know anything we just have to ask.

Anytime there is something I don't understand, or don't know the answer to, I always ask them to show me the answer in a way I can understand.

When I worked in my shop I often found myself in a position where people would ask me the answer to something I knew I had no idea how to answer. Next thing, my mouth would open and out would come what sounded like a correct answer. I would often research this and found I had given them the correct information they needed.

But by far the most wonderful story is when a young couple came in and asked what I could suggest to help them conceive. I was a bit taken back at first, and my logical head thought, "really, what sort of a question is that, do they need a biology lesson?" Then I found myself telling them to purchase a large piece of rose quartz and put it in a certain corner in their house. I

can remember thinking, "blimey, I hope that works", because I was not really comfortable selling such an expensive item if it didn't! But this was my turn to trust. I did ask them to let me know how they went on. Twelve months later I received a card which confirmed the best news, they were the proud parents of little baby Noah.

So if you want to know the answer to something and you are unsure of who to ask, just ask "The Upstairs" as they have all the answers we need. Of course working with "The Upstairs" does require a high level of **trust**, which is the other key thing you need when connecting. We have to trust what we are receiving.

I can't tell you how many times I have thought "am I just making this up?", or "did that really happen?". All I can tell you is the more you trust the better it gets. They will never let you down.

Look after you

We are all guilty at some time or another of not looking after ourselves and not enough importance is given to looking after our physical, emotional, spiritual, and mental bodies. We often look after and treat others better than we would ourselves, leaving ourselves last on the list. But it is not selfish to look after ourselves in a healthy, balanced way, sometimes it is essential.

Angels often talk about feeding your soul – doing things that make you feel good inside. Try to become aware what that is for you. With our busy lives and taking care of everyone else's needs before our own, we often have no energy left but to flop into bed, and that is when we are neglecting ourselves.

So, take the time to work out where you are happiest. Is it in the garden, walking in the woods or by the lake, going for a trip out to the seaside?

Try to bring more activities into your life that will nourish you from the core and bring peace. It doesn't matter what they are as long as they are right for you. Taking time to have that relaxing bath, maybe allowing time to meditate or read that book you have wanted to read for ages, listening to your favourite music, or just sitting down with a cup of tea and not feeling guilty that you should be doing something else!

By doing these things and feeding your soul, you will find it easier to connect to Angelic help which will come your way. The one thing which is good for everyone's soul is to laugh. The Angels talk all the time about enjoying what you do, life is meant to be enjoyed and your Guardian Angels really love to see you have a good laugh.

Chapter 7

Meet your own
Guardian Angel & Archangels

Archangels are the bosses of the other Angels

Everyone has at least one Guardian Angel, though often people can have two or three. They are with you all the time and have been since day one, but the likelihood is that until now you may have not been aware of them and how they can help you.

So how are you going to know how many you have or what are they called? I believe we should find this out for ourselves, not be told by someone else. We all have the ability to connect to these other realms, so by learning to do this for yourself means with practice you can get the answers you need for yourself.

As I have said before, there is nothing complicated about connecting, and learning their name is something quite simple. Having full conversations may require a bit of practice, but I believe it is quite possible if you want to, though this is not necessary

to work with them to enhance your life on a daily basis.

At first, apart from noticing their signs, you may experience your Guardian Angel as a feeling, maybe a warmth, or a feeling of being loved and cared for.

Meditation will help with this, and I have my meditation CDs to help you, but you can also try by doing this simple exercise:

An exercise to meet your Angel

Sitting quietly, undisturbed remembering your Guardian Angel is always with you, ask them to come in close to you. Your Guardian Angel may be behind or beside you, and they may wrap their wings around you and surround you with a great big Angel hug.

You need to be aware of what you are noticing; it may be a tickle from their wings, a warm feeling, tingles, goose bumps and just a lovely sense of love. Whatever it is, you need to acknowledge it and trust it is your Angel.

Generally, people feel really loved unconditionally, cared for, truly understood, it may even feel emotional. You may see something like a colour or a shape, you would be incredibly fortunate if you saw a full Angel, but it is possible.

Just enjoy this time, recognising how it makes you feel and what you are experiencing. Then when you ready, you can ask your Guardian Angel his name. You need to take whichever name first comes to mind, no matter how daft it sounds.

This will be the right name as your Guardian Angel will communicate just how you need them to. The fact is, really Angels don't have a name as such, but we as humans like names and because of this they will give themselves a name that works for you. So don't be surprised if it is a strange one.

Thank your Angel for coming in close so you can experience them. You can ask questions at this point and the answers may well just drop into your head, or turn up later in the day. But use this exercise regularly to build up your relationship with your Guardian Angel.

If you are new to this sort of thing, you might need to try a few times before you realise you are experiencing anything. I say realise, because I believe your Guardian Angel will be there coming in close for the first time, but you might not be open enough to notice their signs. Don't forget this is where the trust comes in. Trust what you are experiencing is your Angel.

My Angels

When I first started to work with my Guardian Angel and the very first time asked his name, I really doubted it as he gave his name as "Geoff".

Now back then I thought, "well, that really can't be right, as Angels are not called Geoff, they have fancy Angelic names". I really questioned my whole belief of Angels because, if I am honest, I thought I must have been making it up in my head. Even though I knew they had been helping me get through my divorce I seriously questioned my sanity!

So, I checked and checked and re-checked. Each time I got the same name "Geoff". So that was it "Geoff" it was going to be, then I realised, he had personalised his communication with me as I am dreadful at remembering names. However, I will remember the name Geoff, as I had two family members called Geoff.

So, if you are unsure of the name you have been given, next time you meditate or ask your Angel to come in close, ask again for the name for confirmation. But remember, because you can have more than one it may be your other Angel that communicates the second or third time with you, so you may need to do it a few

Drawing by Amy Goldup

72

times for real confirmation.

For years I only knew about Geoff, and then, as my relationship grew with the Angels I found I had two others that I started to sense around me. They have very different energy from Geoff and that is how I can tell the difference between them. One who calls himself Lucas (Look As), he helps me work with others to connect with their Angels. I like to think of his name as he is helping me 'look as' Angels would at others and not be judgemental. The final one uses the name Chloe, she helps with my work, such as writing this book. I guess you could say she is not my PA or VA but my AA - Angel Assistant. We all have one, so if you are in business you can be using your Angel to help you too.

You can ask your Angels to help with anything, either for yourself or others, or even the whole world, but as they only work for the highest good of all, you are never going to do any harm by asking for their help. Try asking them to help your family members or friends, or ask for help when you hear of natural disasters, or for peace and calm where there is trouble building. You do not need to only ask for yourself, and somehow, by asking for others it strengthens your relationship with "The Upstairs". There is a whole bank of extra Angels that you can ask, you don't need to just ask your Guardian Angel as his role is to help you. So keep it open and just say "Angels please can you …"

Remember, this is what they are there for and it makes them happy and fulfilled by helping us. We can't ask them for too much help. But do remember to say thank you afterwards.

Archangels

If you wish to keep it really simple you can just leave it to your Guardian Angel to sort it all out for you, you don't need to make it any more complicated because if they can't help you they will re-direct your request to someone higher.

But I feel as so many people talk about Michael, who is an Archangel and they seem to work with him, I thought I should mention the four main Archangels you may have heard about, and how they can help you to.

As well as having our own Angels there are Archangels too! They supervise the Guardian Angels and the bank of other Angels whom you can call upon at any time for extra help. Archangels are very powerful and give immediate assistance, but like the bank of Angels they are not personal to you like your Guardian Angel. Archangels are so powerful that they can help everyone all at the same time if necessary. Again, like your Guardian Angel they are here to help and more than happy to do so, so please don't think "I better not ask" because somebody else may need their help more than me.

There are many Archangels and each specialises in different things, but the 4 most common that you may like to connect with are...

Michael

He is a mighty Archangel, who has a large sword with him. He is here to take away your fears and give you courage. Often people have heard about him and say he is their Angel, but he is in fact everyone's. But like your Guardian Angel he can't help you unless asked. So whenever you have worries and fears ask Michael to cleanse you and take away your fears. Ask him to give you courage with the situation you are faced with.

When we see flashes of light from our Guardian Angels they are bright, white sparkles, but Michael's colour is a purple-blue colour.

Michael can also use his sword to help you, it cuts cords with people so people can't drain you, this can be people from your past or people around you now, whose energy affects you.

He is wonderful at helping with mechanical or electrical problems, even computers, and is great, like your Guardian Angel, at helping you find things, so if you lose something ask him to help.

Michael is a very adaptable Archangel, who can help in many areas of life, and people often find it really easy to connect with him.

Gabriel

This is the only Angel I want to say she rather than he, as Gabriel has a very motherly, nurturing nature. Of course, she is also called Angel of good news as she was the Angel who told Mary she was expecting a baby. So if that is what you are wanting it is a good idea to ask Gabriel to help, even if it is adoption.

Her flashes that you may see out of the corners of your eyes are a coppered colour.

She also helps with anything new, i.e. business, so ask for her advice. She is very creative so wonderful help with writing or drawing projects. She can also help when you need to unravel dreams, as often they can be important messages.

Raphael

I call Raphael the Doctor as he is the doctor of the Angel realms. He can help with all forms of healing, physical or emotional. His light is a beautiful emerald green.

If you work within healing, either medical or holistic profession, ask Raphael to give you guidance to help you heal others. If someone is ill and needs healing, ask Raphael, he will help unless it is time for someone to pass over. When you have asked Raphael for help, he may not always heal you directly, but may guide you to go to someone else, trust what you receive and follow the signs.

He also guides and protects people on spiritual journeys as this is a healing, so ask him to smooth your way for your journey of development. Not many understand he is great at smoothing journeys with travel too, so next time you go on your holidays, ask Raphael for the transport to be on time and for your luggage not to get lost.

I personally always ask him if I have a pain that I need relief from, try him next time before reaching for the painkillers.

Uriel

Uriel is the Angel that meets you at the gates of heaven.

He likes to smooth relationships and worldwide problems. So if you are having trouble with others he can ease your heart and mind. He helps us see love where we think none exists. So you can see the good inside all.

He can help in times of natural disasters, so call upon him to assist when you hear of one. He can help with peace of mind, helps us create a calm and more centred life. His energy is in pale yellow. He gives us great ideas and helps us to manifest what we need.

To Angel and Archangels no job is too big or too small. They love us and just ask that we give thanks.

Chapter 8
Trouble shooting

What to do when you fall off the Angel wagon!

So you are doing great, you have learnt all about Angels, what they can help you with, you can even learn your Angel's name if you want. But there will be times for all of us when we can feel a little disconnected from "The Upstairs", this is normally when we stop connecting, stop asking for help and stop noticing the signs. Often it is not a deliberate act, but done just because life has taken over, we may be facing difficulties and they are consuming us.

What happens when you have developed that relationship and all is going well? You feel fully connected, things are happening as you would wish, life is just slotting into place and then – bump, you come crashing back down with an mighty bang and it is what I call 'falling off your Angel wagon'.

When you have fallen off your Angel wagon you may start to feel a whole host of things and none of them will be pleasant. But be assured they will be short-lived.

You feel you can't connect anymore.

 You are not noticing the signs – you can't remember the last time you saw a feather.

 You seem to be coming across problem after problem, and life is not going smoothly anymore.

 You may feel you have lost your direction.

 You are asking for help but you feel you are not been answered.

 You feel lonely, frustrated, annoyed, after all you are still doing everything like you were supposed to and now it feels as if the Angels have given up.

The reality is the Angels never give up on us, they never stop helping us when we ask. But it is so easy to get wrapped up in day to day life, take things as guaranteed because we have come to expect it. But working with the Angels is not about that kind of relationship.

Even when we feel that they have stepped back and left us alone, it is not true. But it is so easy to believe that we have been abandoned, because as people we have come to expect that we may be let down as people do not always do what they say. But this is not the case with the Angelic realms, they will never leave you, never give up on you, they have so much patience it is crazy. But after all they are the Angels.

This is the time when our trust is being tested and we need to pay more attention to how we are seeing things, maybe we are missing important information. Maybe, we need to slow down, stop panicking, trust they will deliver the help needed. Or, maybe we need to re-think what it is that we are wanting help with, is if for the highest good of all? Do we really need what it is we are asking for? Remember also, if it is someone's time to pass there will be nothing the Angels can do to stop that.

But nevertheless, this experience can really knock people sideways, but thankfully it is usually short-lived and you will soon find that actually your Angels have not gone and left you. It may be that you have been

missing their subtle signs as they may have changed the way they communicate with you. Maybe you always saw feathers, now you keep seeing rainbows. But because you always connected the feathers with your Angels and now you are not seeing them – you thought you had been abandoned.

I know myself I have had periods of feeling lost with it all, feeling really let down. It made me feel quite panicky, as the Angels are such a big part of my life. When this has happened for me it is usually when I have not given myself enough time to connect in – times like school holidays, when there doesn't seem enough quiet time for me.

When we are going through a period of feeling unconnected I would always recommend stepping up with the meditation and slowing down with life. So, by connecting in with meditation and improving communication plus slowing down in life, you can pay attention to the signs that are being shown to you but you are missing them. This is when trust comes into its own, you have to trust that they are still there wanting and willing to help you where they can, so go back to basics, but don't see it as a backward step, but a strengthening one.

Sometimes we can just forget to ask, because we are in panic mode instead of asking for help and trusting the Angels. I can remember clearly some years

ago when I had lost my keys, so we couldn't go out the house and we were already late for an important appointment. I was frantically searching with panic slowly rising, when my son said to me, "Why don't you just ask the Angels to help?". Why didn't I think of that? I couldn't believe it had never even crossed my mind. So I did ask them, and next thing I remember I had a different coat on the day before, when I looked in the pocket there were my keys! Simple really, but in the rush I had just forgotten to ask.

My Angel intuitive cards are a wonderful way of developing your relationship with your Angels. They can give you the guidance you need in a really uncomplicated way, especially handy when you think you have lost your connection. They are so easy to read, there are no hard and fast rules, just do with them what feels right. You may like to pick a card a day or maybe do a daily 3 card spread. There is even a Yes and No Card in them, so you can get a specific answer. But one thing I always recommend people to do is work intuitively with them, and not just use the leaflet that comes with them, so do what feels right for you.

Keeping an Angel journal is another great way of recording your Angel's signs and helps you link them together. It becomes a beautiful collection of Angel evidence that you can look back on when you feel a little disconnected. It is also handy to keep next to

your bed, so you can record your dreams as they are often messages too. We all know that remembering your dreams can sometimes seem impossible, but as soon as you are awake if you can recall just part of your dream, make a note and it will soon unravel so you can understand the message behind it.

I also recommend that when people are first working with their Angels it is handy to keep reminders around the house, or even in your car, so you can remember to ask for the help you need. This might be an Angel ornament or picture.

Cord cutting

We are all essentially energy, everything is. As people, we deposit bits of our energy as we go about our day. If you go to a meeting or night class I bet you like to sit in the same seat each week or have your favourite chair at home. That is because you leave bits of energy there, residual energy, and when you sit there again it feels familiar and comfortable.

We all can be affected and absorb other peoples energy too, and some more than others. But your Angel can help with this too.

It is a good idea if you are a person who takes on other people's problems to clear yourself and set the boundaries. Ask the Angels to help you.

You also ask Archangel Michael to cut the energy cords that are between you and others, these are attachments or hooks that others can put into you. This type of relationship will leave you feeling drained, we have all met human vampires. The friend who comes round for a cup of tea and bends your ear about her problems, when she leaves you are exhausted.

Cord cutting does not mean you do not love them anymore, but you are stopping them from draining you.

It is really useful to cut off attachment to an item you are wanting to, especially great for house sales. For instance, someone unable to sell their house, they may have cords attached to the house and need to cut them to get the sale. You just walk about each room asking Archangel Michael to cut the cords of attachment, giving thanks for the shelter, warmth and home the property has provided and welcoming another family or person in.

As you go about your day and you come across someone who is negative and their mood is affecting you, visualise you are surrounded in mirrors and it is bouncing back onto them.

The more Angels you ask to be around you the more support it gives you. It gives you more love and protection and repels problems around you. You will find everything easier and you will have a glow and a

special energy that people will comment on.

It is easier to hear Angels' voices in the right environment i.e. music, fragrance etc. as they shift our vibrations to a higher level. Try using incense, Angel or even classical music.

Angels don't just bring you guidance, they can bring protection, you never feel lonely, they bring information, moral support, a pat on the back, and importantly, unconditional love.

To communicate easier, think before you speak, think only kind thoughts, say only kind words (when possible!).

By thinking and saying kind things it clears the communication as it purifies our aura and energy, again ask the Angels to help.

Regular cleansing of your environment is a good idea and definitely necessary when you move into a new home, or bring a new piece of furniture in. This isn't getting out the vacuum or polish but cleansing can be done by burning white sage sticks and wafting the smoke around the item, or into the corners of each room; you could use incense too. Noise works also, so bells could be used, or if you are a crystals lover, some carefully positioned crystals will do the same trick. Don't forget you can also ask Archangel Michael to clear the area too.

Chapter 9

Manifesting with your Angels

Creating your dream life with your Angel's support

So, what is manifesting with your Angels? It is creating with energy and bringing what you want and need into your life with your Angel's support.

Believe it or not, everything you have in your life, you have created it; the good, the bad and the ugly. I know this is hard to believe sometimes, but it is true. We all manifest naturally, it is as natural as breathing. But when you do it with your Angel's support and consciously rather than subconsciously, it becomes very powerful, that way you can start creating what you want, rather than what you don't want.

Abundance to the Angels is not how much money you have in the bank, but the quality of life, your health, friends, family etc. But it is fact we need money to survive in this world, and the Angels understand this and will support it. I believe there are three main things to manifest, love, health and money.

Most other things can be bought with the money. So all my principles of manifesting with your Angels are based on these three things.

Working with your Angels to enhance your life may sometimes seem a greedy, selfish thing to do. But everyone has access to them, so everyone can change their life for the better. It can only work when done for the highest good of all, not to get the better on someone.

I always recommend when people are learning to manifest with Angels to start with something small, such as a parking space. When you see with your very own eyes how easy a parking space can just materialise when needed, it will give you the confidence to try for other things. You don't even have to be the driver of the vehicle.

Working with your Angels to enhance your day to day life is about working with love, being the best person you can be. Not just saying nice things and doing kind things because you feel you should, or it is expected, but really doing all of this from your heart. This purifies your energy, makes connection easier, you start to shine and people start to notice and comment on your energy because it is coming from a place of love. It makes you feel so much happier, too.

It is about loving yourself, loving others and loving the world we are in. Having gratitude for what we

have already, even the things we don't really like or would like to change. This also goes for past relationships and difficult lessons we have faced, we have to have gratitude because we have learnt and come out stronger, so even if you are just grateful for the lesson gratitude is the only attitude we need.

The first thing you need to do is have head and heart in harmony, and your Angel will help with that. Is it no good asking for something you don't think you deserve. That will just cancel your order, you need to know you honestly and truly will receive it.

Doubt, limiting beliefs and blockages need to be cleared before you start too. Maybe you were brought up with the saying "you have to work hard for your money" or always being told you were not good enough. These may well have stuck and be preventing you from achieving your dreams.

It is worth remembering this when we are having a bad day, if we focus on everything that is going wrong, we will get more of it, so ask the Angels to help you get it into perspective.

You need to give up thoughts like...

"everything is hard work"

"things never go right"

"I never have enough money".

Replace them with...

"things always work out for me"

"I can get this done, it is easy"

"money comes to me easily and effortlessly"

because what we are expecting we get and I know what I would rather expect! There is definitely one thing that stands out with all of this and is easy to put into place...

Positive attracts positive and negative attracts negative. So by just being a bit more positive each day will attract more positive things to you and you will soon notice a difference.

What you are thinking and feeling about you will attract it to you, we are magnetic.

You are putting your requests into the Universe, but being supported by your Angels.

The Universe cannot deliver unless you put your requests/order in. But because we can do it without even realising it, we can end up ordering something we don't actually want or need, because we get what we focus upon.

This is what often happens when we are having a period of everything going wrong. For example, when the kettle breaks, then the washing machine, you are expecting a third thing to go too, because you

are expecting it will happen. Simply because we are focusing our energy on that happening it appears in our life, we attract it in.

You can manifest in many ways, just think it or say it, or you can write your requests down. It is no good ordering something you don't think you will receive or deserve as this cancels your order. Also, as soon as your doubt creeps in that also cancels the order.

Don't over-order as if you ask for too many things at once you can't focus on believing you will receive so many things, so keep it one thing at a time if possible.

The difference between any other type of ordering and manifesting with Angels is using your heart.

You have to really feel, love and want it, and then you will receive it. Angels will help you whilst you are waiting and it won't be a roller coaster ride!

Step One – Ask

Decide what you want or need, ask the Angels to help you to know what you need.

Step Two – Believe

Use your imagination going forward in time, and you have already got what you wanted. Imagine how that feels, how does it look, smell, hear or even tastes! You have to really believe you have it. Ask your Angels to show you, with love. The Angels will help. Don't think you are just dreaming, it can be your reality. You have to believe. Say thank you to the Angels for the manifestation they are bringing you.

If you are not good at visualisation, it is good to have a visual prop to keep looking at e.g. vision board, toy car, holiday magazine.

Step Three – Receive

Sometimes it is not just a case of waiting for it to turn up, it depends what you ordered. So you need to pay attention to your guidance and trust your instinct when you are manifesting, this will lead you to your manifestation.

Remember:

 Don't force and try too hard, or repeat your request as this comes from fear that you won't receive what you have asked for, and will cancel your order.

 Use that energy to relax and expect, visualize your manifestation using all your senses as if it is with you now.

 Make sure you surrender your desires, be honest about what you want.

It is very important to follow all the guidance that will come to you through manifestation. You may need to look back if you become stuck to see if you have missed something. Watch out for coincidences, again ask the Angels for clarification.

So, give it a go, ask for something specific, don't generalise. Start with something small like a parking space or something random like a yellow car, or a sunflower, and work up from there.

The list of things I have manifested and helped clients to manifest is amazing. I personally have manifested better health. I have gone from living in an ex-council house to living in an amazing 15th century farmhouse that won ITV's "May The Best House Win". I have manifested furniture for free overnight and one

of my latest achievements was manifesting my dream car. What will you create when you learn to Manifest with Your Angels?

This is only a small section on how to manifest, look out for my next book, this will cover it in great detail. Or take a look at my website: **www.theangelmystic.co.uk** where you will find details of my home learning and VIP programmes.

Chapter 10
Other Angel evidence

We all experience Angels in different ways, the way we need to because our Angels will appear to us the way we need it. Scattered throughout the book are some real life examples, but here are some more. They are all real life stories that either I have experienced or someone has kindly given me permission to use theirs.

Each one is individual, and each one special to that person. I am hoping by reading about them you will understand more how your Angel will communicate with you.

Real life stories

Holiday with the Angels
by Amanda Tooke

My children and I took a trip to Spain, the Angels were fantastic with easing all the travel arrangements and helped with the hiring of a car and driving. We didn't get lost once, which for me is a miracle!

However, our accommodation was not up to much and we went in search of something more suitable so not to ruin the holiday.

We found a lovely hotel overlooking a beach, it had a pool and looked clean. So we got a price from the receptionist and went to look around. She gave us two prices, B&B and half board. Both were more than I wanted to pay, but the hotel looked really nice and was catered to families.

I asked the Angels if they could help with the price and went back to the desk to sort it out. The receptionist went back on to the computer, and after a few clicks here and there, she looked at the screen, puzzled. She called a colleague over to check. I started to think, "Oh no, the price has gone up, we can't afford this", but then she looked up and told us it was ok, that the price changed, but that it would turn out better for us.

The price changed right before her eyes. The computer now showed a half board price for all of us for less than the original B&B price. Those Angels are really good! I couldn't believe it and when I picked my bag up to pay there was a little white feather right next to it.

Car Breakdown
by Angela Edwards

I recall many years ago (in the days long before mobile phones) I had been on a night out with a friend. We were driving home when my car broke down at a T junction. It was pitch dark and there was nobody about, all of a sudden a car came from the left and two men got out (they parked on the main road) to ask what was wrong.

After explaining, one of the men looked under the bonnet and said he could 'see' what the problem was, without the use of any tools at all he corrected the problem within a very short time.

I offered payment to the men but was told to 'just pass the kindness on'. The men returned to their car and seemed to have disappeared. It took me many years to realise these men must have been Earth Angels and I am sure that if I could have seen the colour of their eyes they would have been a lovely shade of blue.

Doctor Angel
by Lisa Lydka

On April 18th 2006, the day after his 1st birthday, Louis was diagnosed with Retinoblastoma (A childhood eye cancer). He attended Birmingham Children's Hospital every 4 weeks during and after chemotherapy treatment.

During this he would be put under anaesthetic in order to check on the eye tumour. As parents we were allowed to take him into theatre until he was asleep, but then we had to leave while the surgeons took a look at his eyes.

At which point in my mind I would ask for the Angels to stay with him and look after him. I would also envision beautiful light shining out from his eyes. It was my way of dealing with it and helping me through! He had lots of various cancer treatments that would partly work, but not enough.

This continued until the beginning of August 2008, when on this particular day, Louis wanted his Daddy to take him into the theatre, when he would usually want me to do it.

As I watched his Dad carry Louis down the corridor, there was an anaesthetist leading the way, then Louis and his Dad and a nurse behind. As I did my usual and asked for an Angel to stay with him,

I leaned forward in my seat to watch them walk down the corridor, and following at the back in between Louis and the nurse was a very tall (maybe 7 foot) Angel, with shiny auburn coloured hair and a white gown. I would say this was male, but a classic Angel! For some reason it didn't shock me, I didn't think that I was seeing things! I just had a beautiful feeling of calm.

When Louis came round from his anaesthetic we were asked to go into the doctor's office. We knew that it wouldn't be good news. The cancer was becoming aggressive and we were told that the tumour was getting very close to the optic nerve and the cancer could go into the rest of his body! So there was a decision to remove his eye. I knew straight away (because of the Angel) with absolute peace that this was the right thing to do.

Louis had the operation on 13th August 2008 and has been cancer free since. He is now 8 years old.

Trampoline Assembly
by Amanda Tooke

When we moved house to a larger garden I got the children a big trampoline as they had always wanted one. The problem was the assembly of it. We tried ourselves and that was useless, so we got my brother and a friend to help. Typically no instructions were read and, as is often the case, I just forgot to ask for help from my Angels. So time was ticking on, hands were becoming sore from stretching the springs into place. There was just the last two springs to go and they looked nowhere near long enough.

Admittedly, it was only when one of them was muttering under their breath that I remembered to ask. I told them to stop, I asked and then told them to try again. They both managed easily to hook the springs in place. Looking confused at me they asked what I had done. I told them I had just asked for help. Their response was, "Well, why did you not do that earlier?" This is a good question, but sometimes we just forget, even me!

A sign of Nanna
by Pamela Weeden

My Nanna died in April 2011, and as it was approaching Christmas, everyone was very tearful. Christmas is a big deal in our house; we have a big family get together, eat loads, play games etc – she always loved it and everyone was really aware of the fact she would be missing.

I decided to buy my Mum, my Sister and my Aunts a willow tree Angel to give them on Christmas Day in memory of Nanna. In the shop, I managed to find a perfect one for each – me and my grandma, for my Sister, mother and daughter, for my Aunts and three generations for my Mum.

I didn't say a word to the man serving me in the shop about what I was doing; partly because it would have made me cry. It was near to Christmas and he would have just assumed I was present buying.

As I paid, he suddenly told me to wait. He went out to the back of the shop and came back with a box. It was a willow tree Angel called Stay Golden. He just said "that one is for you." I took it that it was from my Nanna. I treasure it.

Feathers For Comfort
by Diane Toogood

My mother died very unexpectedly, and after a couple of weeks of sorting out the funeral, driving all over the country and existing mainly on fresh air, I arrived home on the Sunday shattered and very heartbroken.

On the Monday evening, my best friend came over to my house, we were sitting in my garden talking about my Mum and suddenly from nowhere there were hundreds of white feathers on the ground.

We looked around thinking a bird had fallen or been shot out of the sky as there were so many feathers. There were no birds anywhere. These feathers just literally appeared from nowhere.

It made me feel very happy and loved as I knew my Mum was saying thank you and I am here and love you. It was a beautiful experience.

Airport Angel
by Angela Edwards

In the airport departure lounge, I asked the Angels to accompany us on our flight. When the gate opened for boarding I heard a 'whoosh' sound from my left, I looked up and saw a huge white energy going through the gate to the aeroplane. Need I say, we had a most enjoyable flight to our destination.

Angel in the Night
by Stephanie Pugh

We had just moved to Wales from Hull. My 4 year old son had had an accident whilst we were still in Hull, he had climbed up a glass cabinet that had a broken toy of his on top. The cabinet fell onto him and the glass shattered in his eyes, leaving him with a detached retina in his left eye. This left him blind in it.

We moved to Wales and he continued to have operations on his eye and face (the glass left many cuts on his face and he had some plastic surgery). The accident had caused stem bleeds in his brain and it affected his behaviour, he would often get up during the night and wander about the house on his own. So I moved his bed opposite mine so I could keep an eye on him. I woke up one night and looked towards his bed to make sure he was still in bed.

Floating at the side of his bed was a beautiful woman, she had a long white floaty dress on and long brown hair. It was as if there was a breeze blowing on her as her hair seemed to be floating backwards, yet there was no breeze in my bedroom. What I can only describe as little golden coloured sparks were flying out from her, but they seemed to look like little cherubs.

I panicked and dove under my covers, hoping that I was dreaming or something. When I looked again

she was still there and she was smiling at my son who was still asleep. I came over all calm and the panic just melted away from me, it was like love, this overwhelming love just flooded through me. I don't know how long she was there but it was quite a while, a good 5-10minutes. Then she just melted away.

I had been worrying so much about my little boy, and her visit honestly felt like a huge reassuring hug that everything was going to be ok. I knew in my heart that I had seen an Angel.

Orbs
by Amanda Tooke

When I was filming for "May The Best House Win" the camera person was upstairs alone in my bedroom, supposedly filming shots of the empty room.

She came down saying there was something wrong with her camera as it had big blobs all over the lens. She spent a time cleaning it all and went back to film, again she experienced the 'blobs'. It was then I realised she was seeing orbs, and this is how Angels can often appear.

Angel Reassurance
by Edwina Scott Russell

A few years ago I took our dog into the vets to be spayed. I was really in two minds about putting her through it and I dithered outside the vets practice wondering whether to go back in and take her home.

It was early morning, with few people about, but suddenly a little old man with a flat cap appeared at the side of me. I honestly don't know where he came from; he asked what was wrong, I told him about our dog and how bad I was feeling.

He touched my arm and said, "You are doing it for her own good, so don't feel bad." I looked at him and he had such lovely twinkling blue eyes.

I immediately felt very calm and said, "Yes, you are right." He squeezed my arm and said, "Well, I better go and get my bread while it is still warm," and off he walked. I glanced back at the surgery door, then back down the road where he had walked and there was no sign of him anywhere, and there was nowhere he could have popped into. Just poof, and he was gone.

I felt happy with my decision to leave my dog and went home with a lovely warm feeling. I was pretty sure it was an Angel reassuring me I was doing the right thing, and the dog was fine and running round like a loon a couple of days later.

Robin
by Alan and Sandra Marsh

Our son Daniel who was born 4 MONTHS prematurely, but we have always felt he was special and well taken care of. He came off his toboggan in the snow a few years back, and as he lay in the snow, a robin landed on him and waited until we reached. I even managed to take a picture of him perched on his chest as he lay still. Needless to say thankfully, he was alright.

Chapter 11

Moving forward and what to expect

Enjoy the journey

By now you should have a good idea how to connect with your Angels and how they are communicating with you.

Like all relationships, the more you put into it the more you will get out of it. A lot of the time it will seem like you are putting trust into something that is invisible to most, and that is a lot to ask.

My way of thinking about it, is that we trust mobile phones work, we can't see them working but they do. So please try with your Angels, as it will soon be second nature.

As we are becoming more open, allowing our Angels in, our spiritual self can develop and we may start noticing more signs, synchronicities and other things going on.

These are some signs that indicate spiritual awakening, may be happening for you such as:

 Changing sleep pattern, waking up two or three times a night.

Food intolerances, such as caffeine, wheat, dairy, alcohol.

Seeing auras around people, plants, animals, and objects.

Getting a buzz or ringing in your ear.

Vivid dreams with messages in them.

A great desire to break free from life-draining jobs or people.

After years of being happy and content with the same job, house or partner, feeling it is not enough and wanting to leave, change your life and be free, creative and be who you really are.

Hands tingling and getting very warm.

Noticing synchronicities.

Wanting to discover the reason you are on the earth for.

But be assured your Angel will alway keep you safe and development will only go at the rate you want it to.

As you embrace your spiritual side and develop your connections with "The Upstairs" you may notice certain signs that can indicate you are being re-tuned. This means you will be more aware and easier to communicate with these wondrous beings. This is an exciting time, and you can learn about the spiritual you, as we are all spiritual beings having a physical reality.

Your interest in spiritual subjects may grow, and you will find "Teachers" appearing everywhere with perfect timing to help you on your spiritual journey: people, books, movies, events, Mother Nature, etc. Take the time to look, enjoy the experience. Most of all have fun.

Allow your intuition to grow, your inner guidance system that has often been sitting dormant is now springing into action, up to now it has been like walking round with a blindfold on.

Start paying attention to your gut instinct or using your sixth sense more. Even if it is a sense that something is going to happen, but you are not sure what. So if it feels right do it, if not don't.

Everyone has potential to develop themselves, we all use our other senses such as sight, touch, smell, taste, hearing, why not use the sixth sense, intuition, gut instinct, call it what you like, it is there to be used to help you.

Do you always know who is on the phone before you answer it?

Or, do you think of someone from the past and then bump into them?

These are all things that may well happen when you start to develop yourself.

Remember a busy life will slow down spiritual development, so make time for yourself to develop. Watch out that you are not staying busy due to fear!

If you feel unsure about what you are been guided to do, ask the Angels to clarify their message.

But remember to start with the simple things like ask Angels to find you parking spaces and move on to communicating regularly through the day.

Angels can help with all problems, but with Angels or Spirit you have to trust what you are getting and act on it.

Try making meditation part of your daily life, even if it is only for 10 minutes. It is the key to spiritual and self development. Who knows what you might discover?

Enjoy your new life with the help of your Angels and be prepared to be amazed.

Going forward with the Angels in your life is something that will become just part of your life, an important and very useful part. But, as the saying goes, you have to use it, so you don't lose it.

Give "The Upstairs" the time and respect they deserve. As with all good relationships you should value and give thanks for it.

Angels all around us, we thank you so,
The good you teach us, the love you show,
Not to be bowed down to, but thanked with love,
For all that you give us, from above,
We have learnt plenty and this is only the start,
Life changing is certain, when Angels take part,
Remember to ask, trust and believe,
This will make certain, you will receive,
Enjoy your life, with new sparkle and shine,
As now you now know, this is your time.

Automatic writing by Amanda

Amanda's other work

You will find all Amanda's products and services at www.theangelmystic.co.uk

Her work is all about helping others discover their Angels, develop spiritually and manifest a dream life. She has a wide range of products to help with this:

Angel and Psychic Readings
Available via phone, Skype or in Windermere

Meditation CDs
Angel Awareness – to connect with your Guardian Angel, receive healing with the Archangels and manifest your dream life.

Rainbow Healing – deep healing meditations for re-balancing the Chakras, forgiveness and un-conditional Love

The Basics – a tool box of exercises to ground, protect and cleanse yourself

Angel Intuitive Cards

Home Learning Programmes

Angel Awareness
Manifesting with Your Angels
Spiritual Development Meditation Programme

VIP Programmes

6 monthly programmes where you can work person-
ally one to one with Amanda to develop yourself spir-
itually and manifest the life you have always wanted.
Available via phone, Skype or in Windermere.

Workshops and Development Circles

Available on line and in Windermere, please check out
the website for full availability and dates.

www.theangelmystic.co.uk